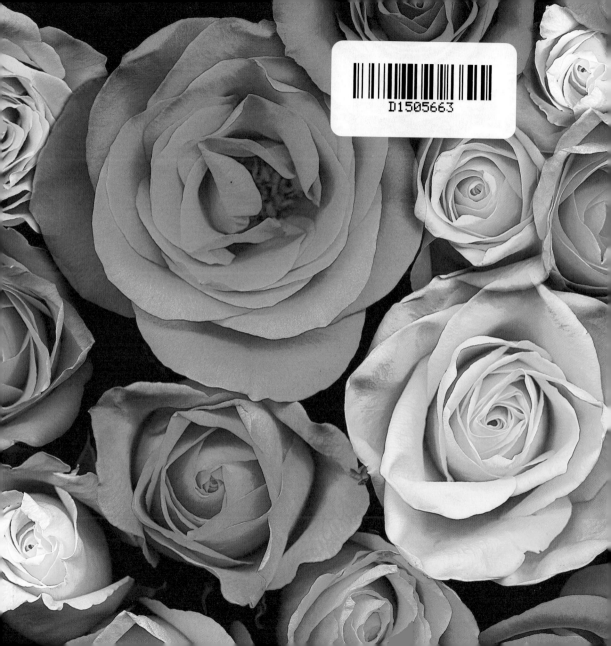

D1505663

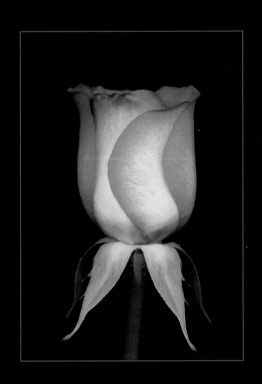

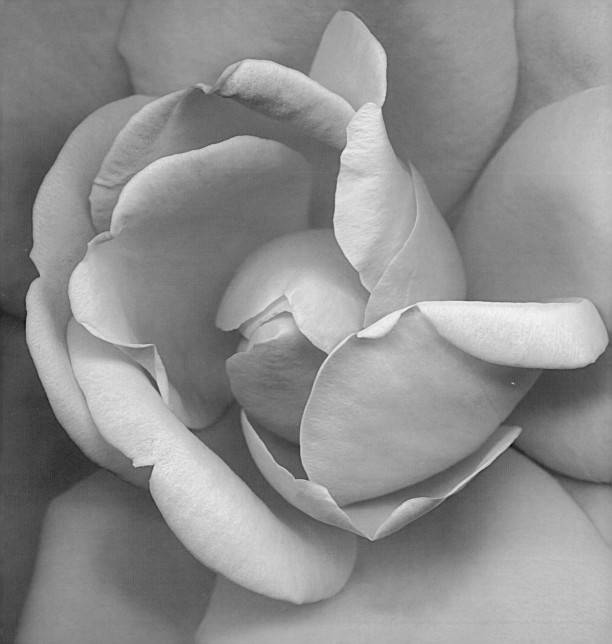

THE INFINITE
ROSE

HAROLD FEINSTEIN

BULFINCH PRESS

AOL TIME WARNER BOOK GROUP · BOSTON · NEW YORK · LONDON

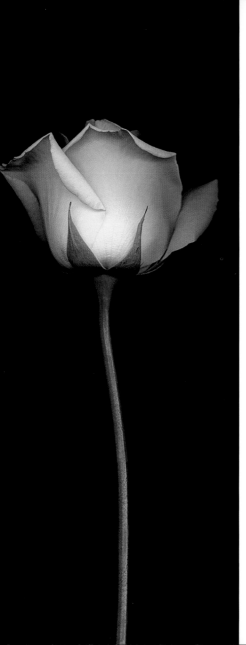

For Lamont Thompson
in memory of Betty Thompson

ACKNOWLEDGMENTS

I wish to thank the following people: Mike Lowe for his extraordinary experience with and generous advice about roses; Lance Hidy for his exquisite design sense and perpetual input in the editing; Cindia Sanford, whose personal involvement with and love of all flowers has been a constant inspiration.

I also want to thank Jill Cohen, publisher, and Michael Sand, editor, at Bulfinch for their enthusiastic efforts on behalf of this book.

My wife and soulmate, Judith, for her warmth, wisdom, and love.

Lastly, I want to thank Fabia Barsic-Ochoa and Dan Steinhardt of Epson America, whose printers and scanners made this project feasible. HF

Copyright © 2004 by Harold Feinstein

All rights reserved. No part of this book may be reproduced in any form or by any electronic or mechanical means, including information storage and retrieval systems, without permission in writing from the publisher, except by a reviewer who may quote brief passages in a review.

First Edition
ISBN 0-8212-2875-7
Library of Congress Control Number 2003112766

Bulfinch Press is a division of AOL Time Warner Book Group.

Design by Lance Hidy

PRINTED IN ITALY

PAGE ONE: BROADWAY
FRONTISPIECE: NEW DAWN
LEFT: JOHN F. KENNEDY

THE INFINITE ROSE

A rose is a rose.

It is also an invitation to enter into the heart of hearts.

Has it not always been an expression of love?

How many ways do I love you?

Come closer! Gaze into my petals.

You may know me, but there is more.

Wander among my colors.

Take a deep breath. Stay awhile.

This is the beginning of forever.

BROADWAY

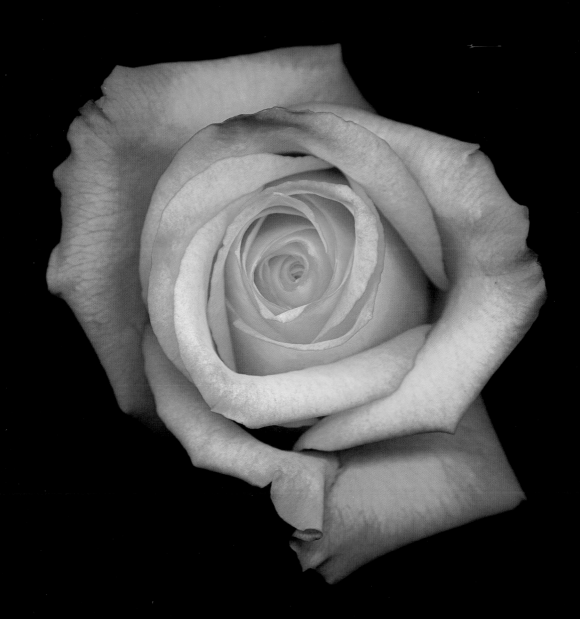

ICEBERG

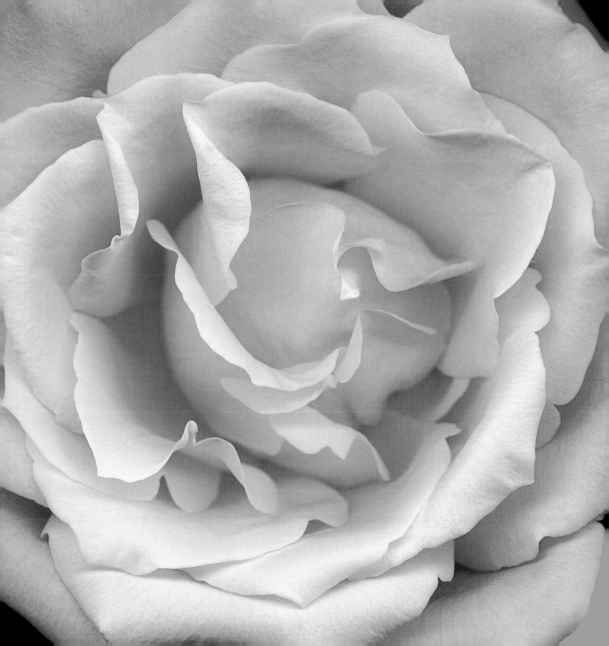

MORGENSONNE

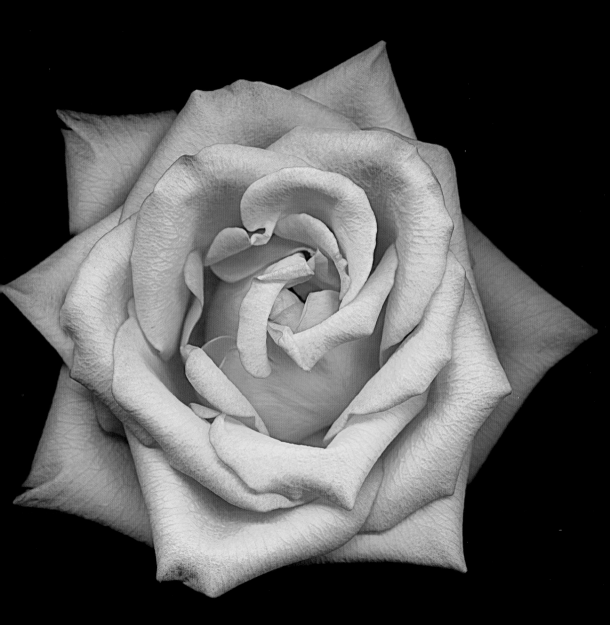

PEARL DRIFT

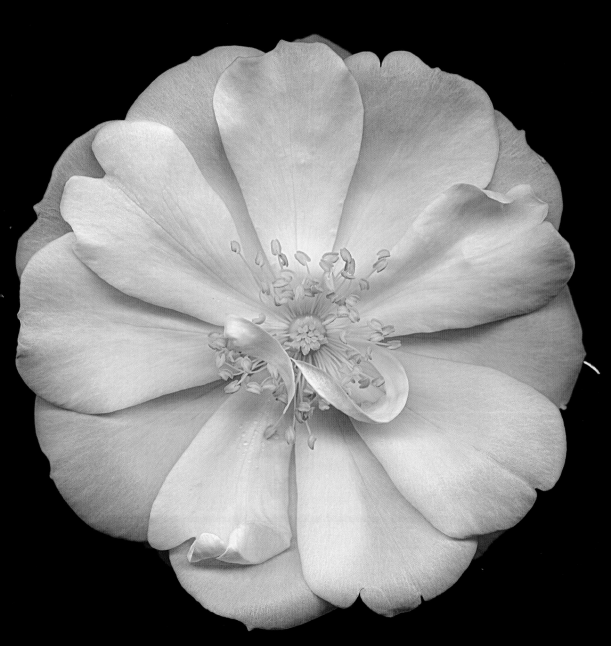

CIRCUS PARADE

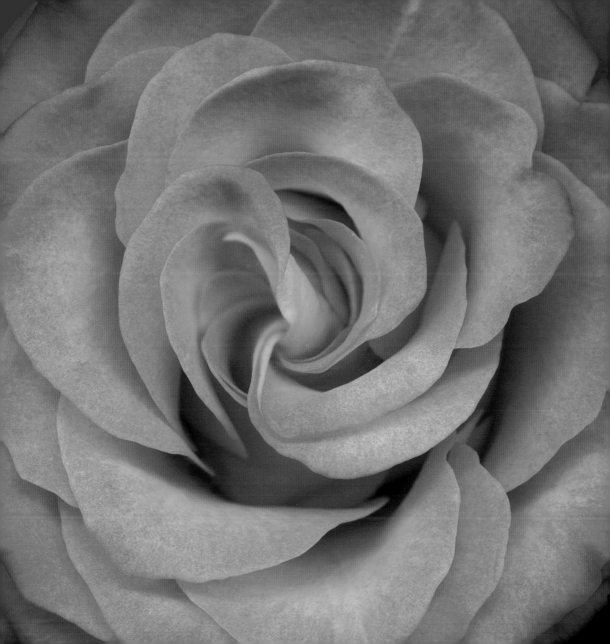

CUPCAKE

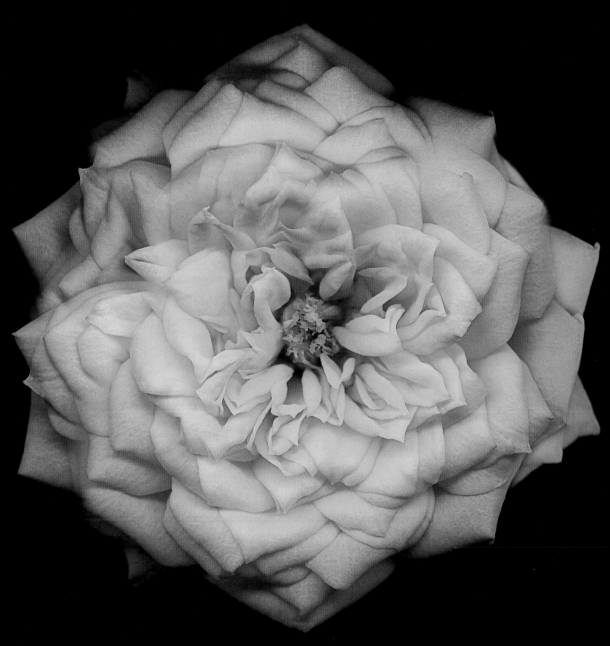

UNKNOWN HYBRID TEA

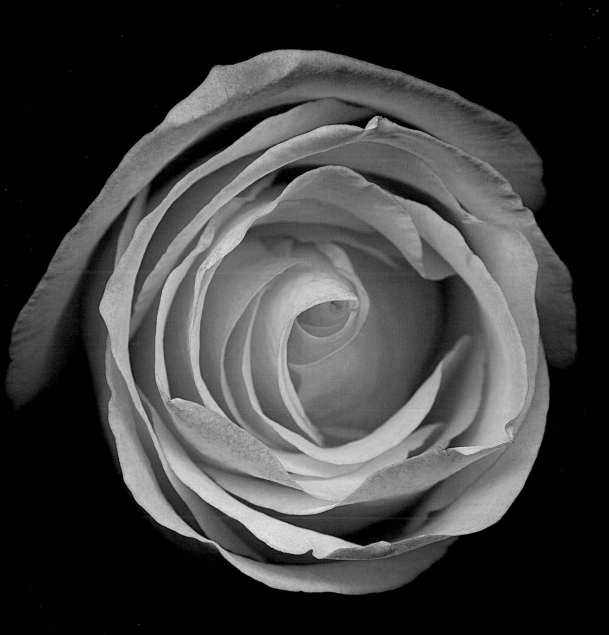

SOUTINE

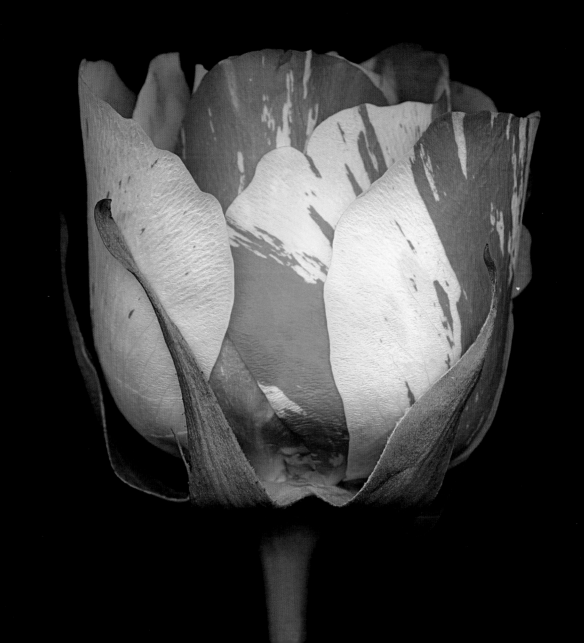

RING OF FIRE

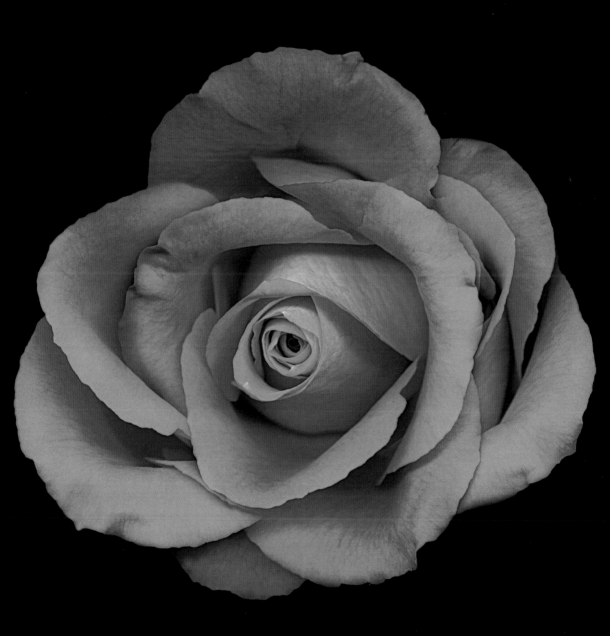

CAREFREE DELIGHT

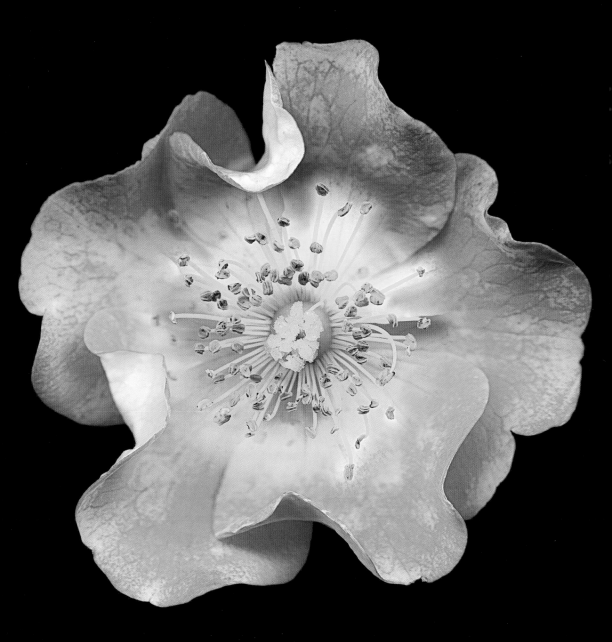

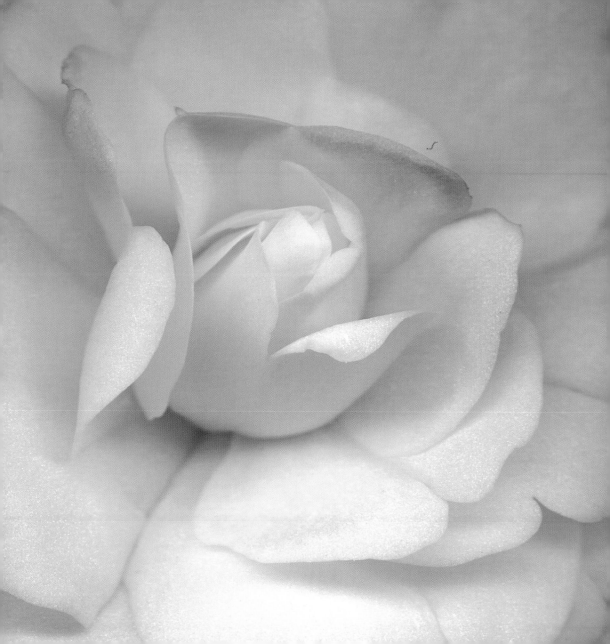

NEW DAWN

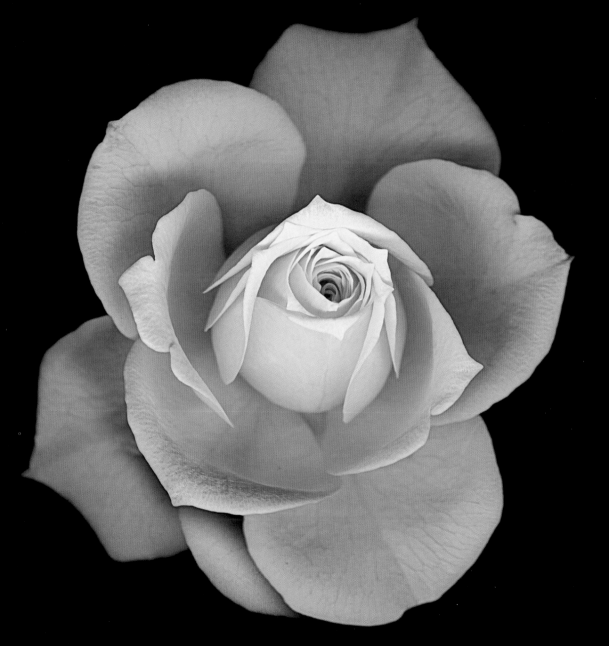

GOLD MEDAL

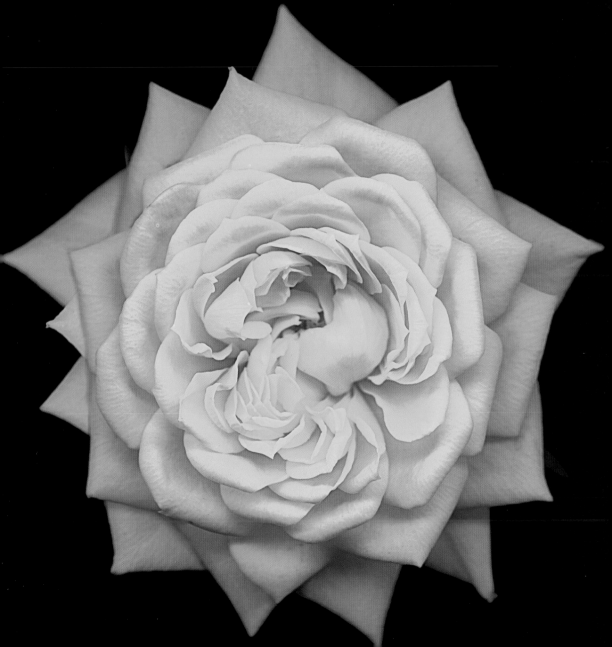

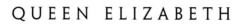

QUEEN ELIZABETH

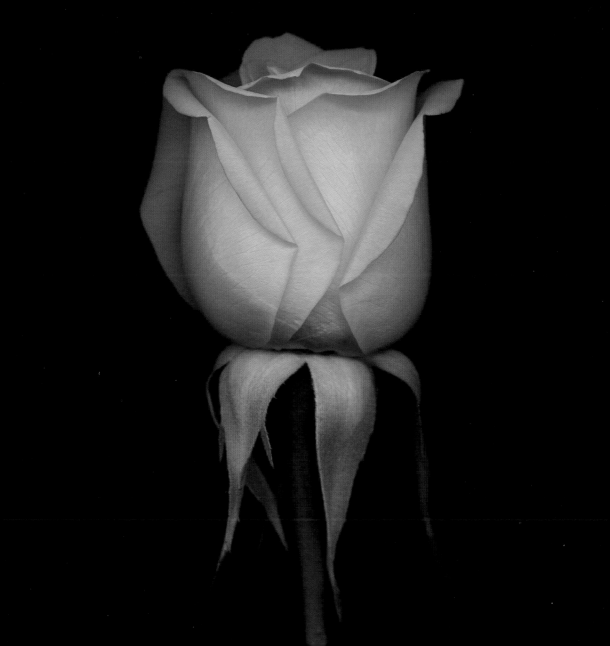

BRANDY

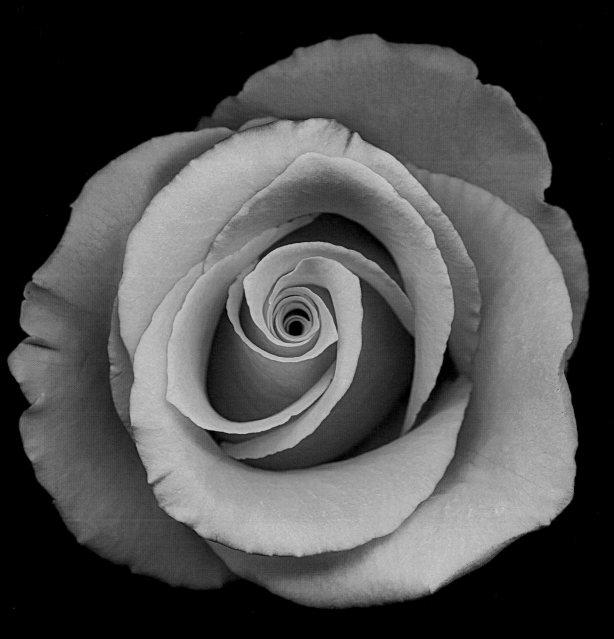

MINILIGHTS

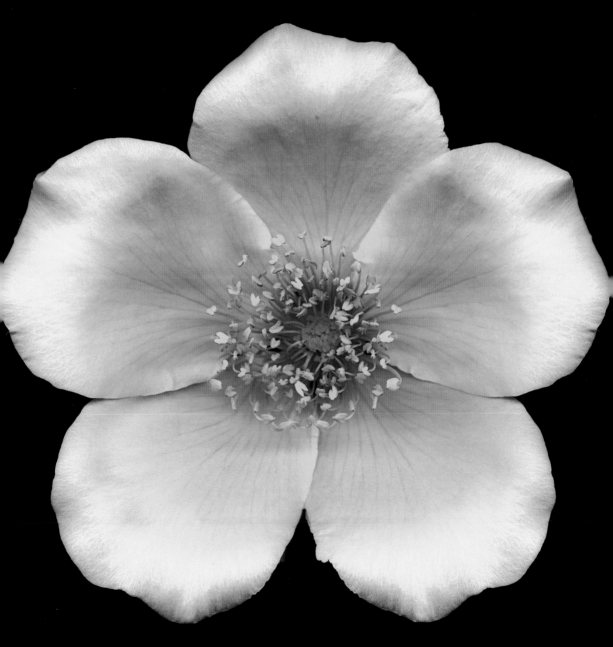

MACMILLAN NURSE

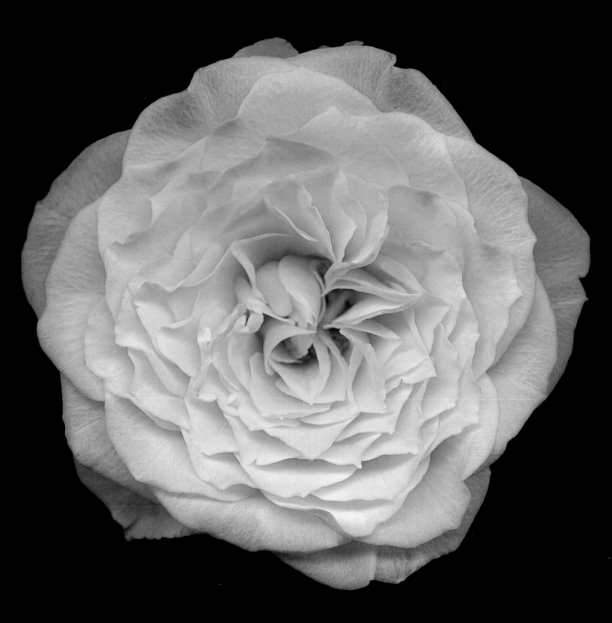

UNKNOWN HYBRID TEA

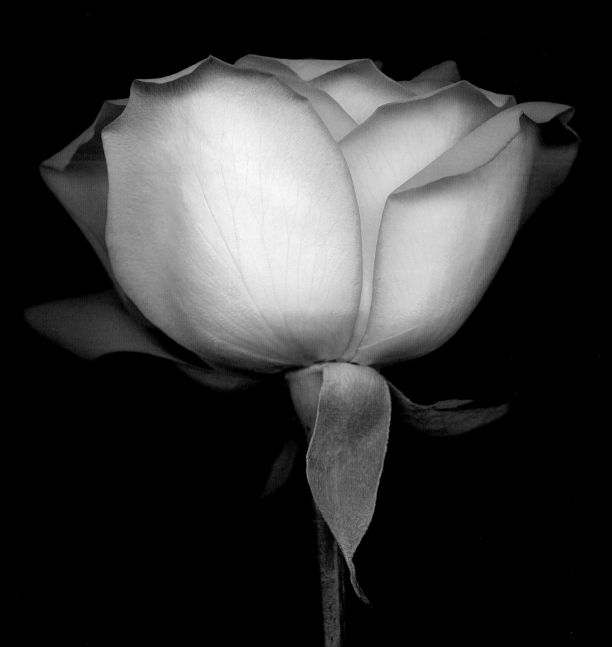

ELECTRON

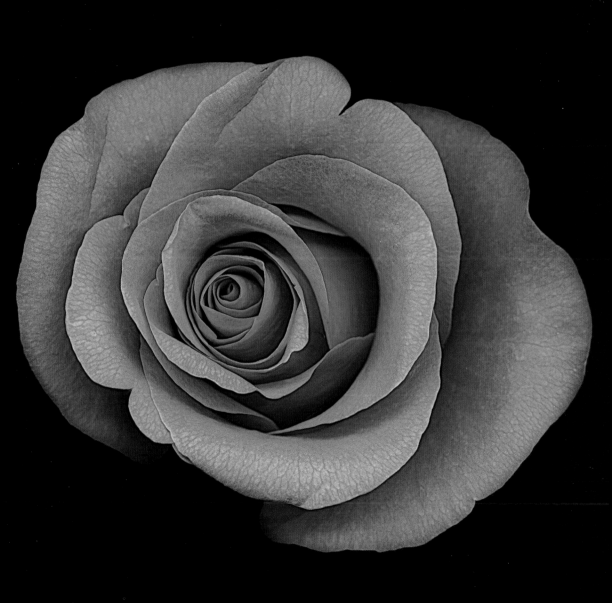

MME. JULES BOUCHÉ

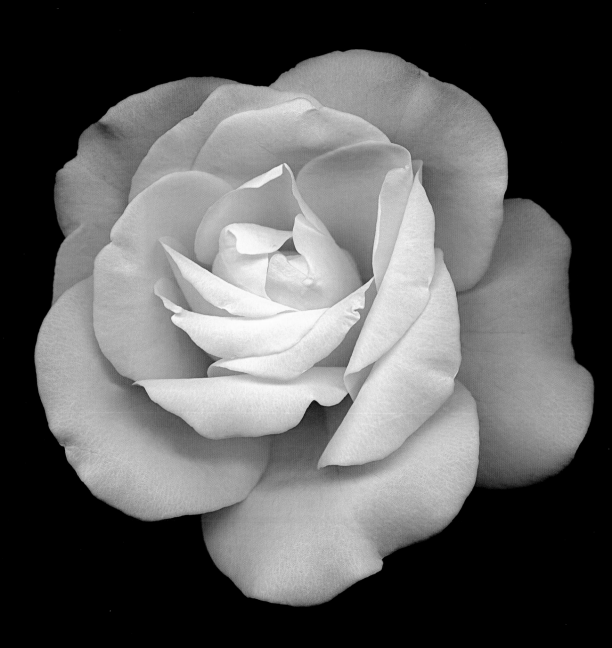

GOLD MEDAL

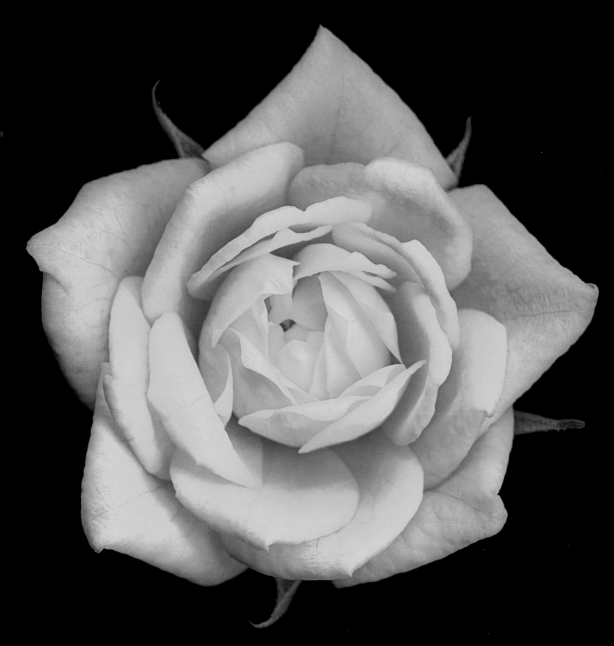

MASQUERADE

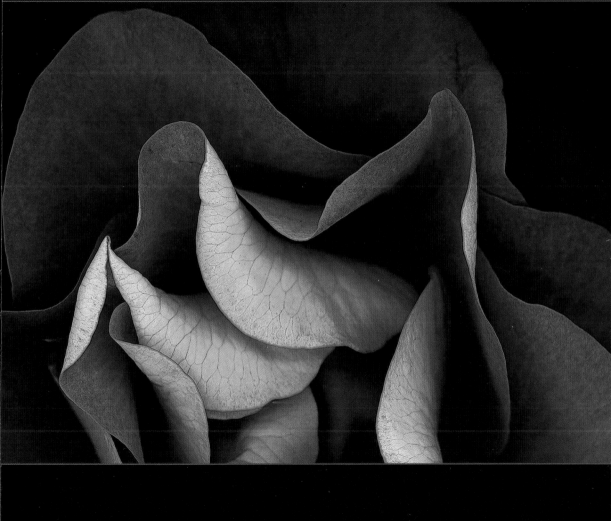

DOUBLE DELIGHT

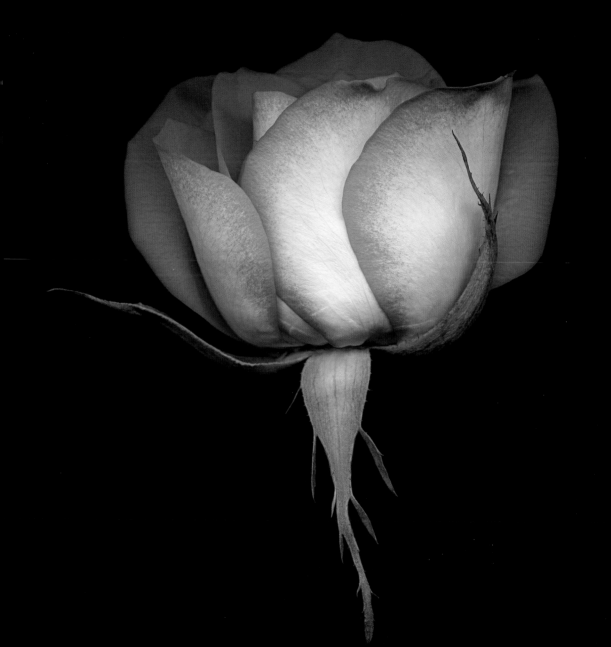

FIGURINE

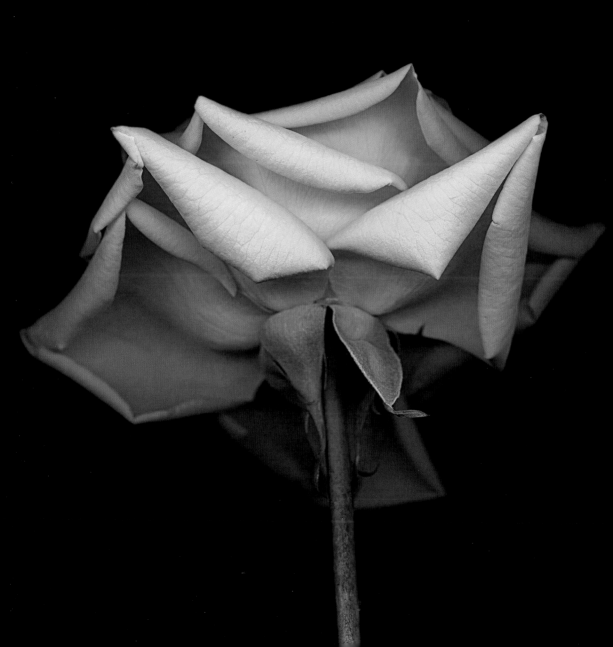

PEACE

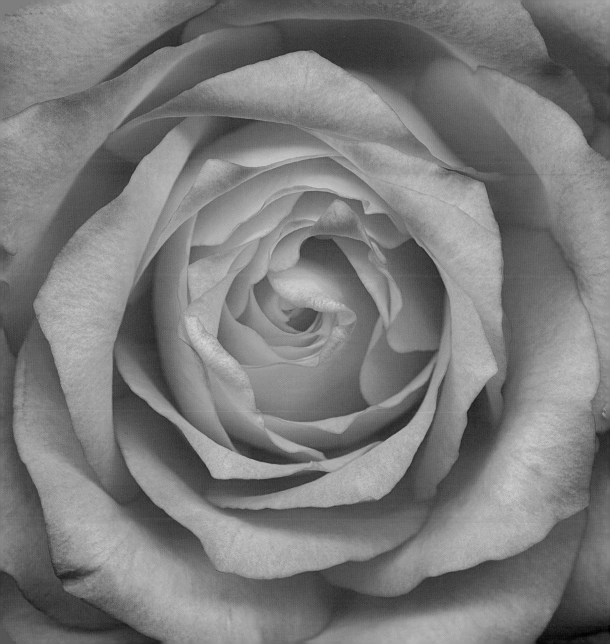

ST. PATRICK

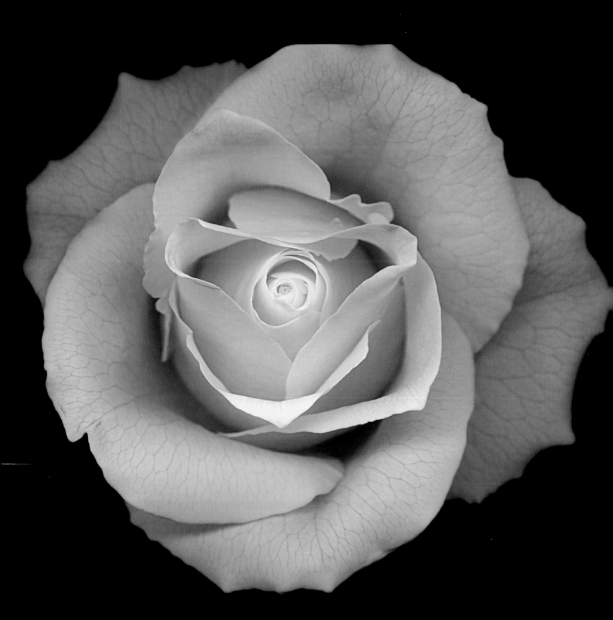

SALLY HOLMES

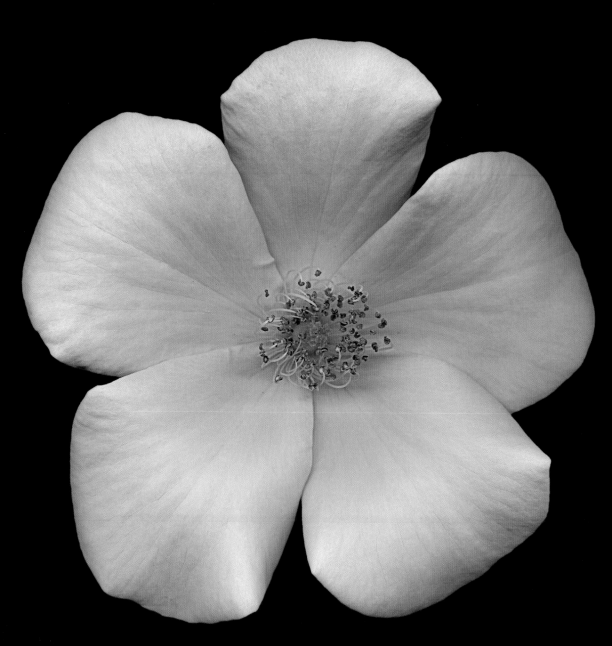

BABY MICHAEL

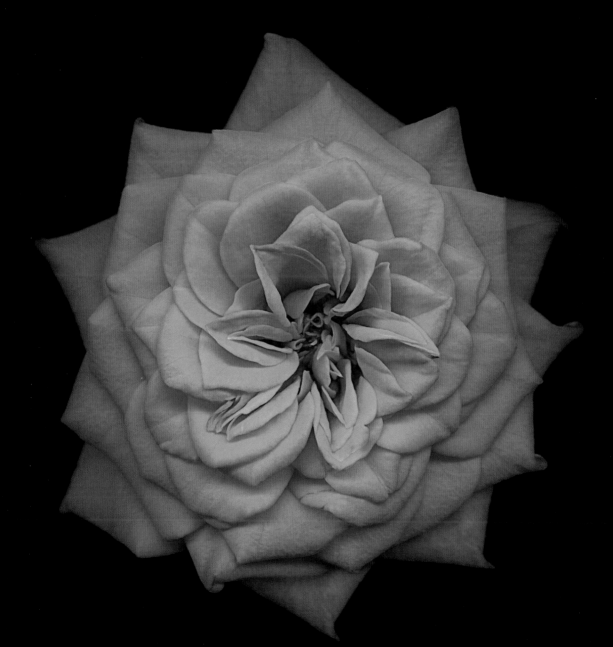

MIDAS TOUCH

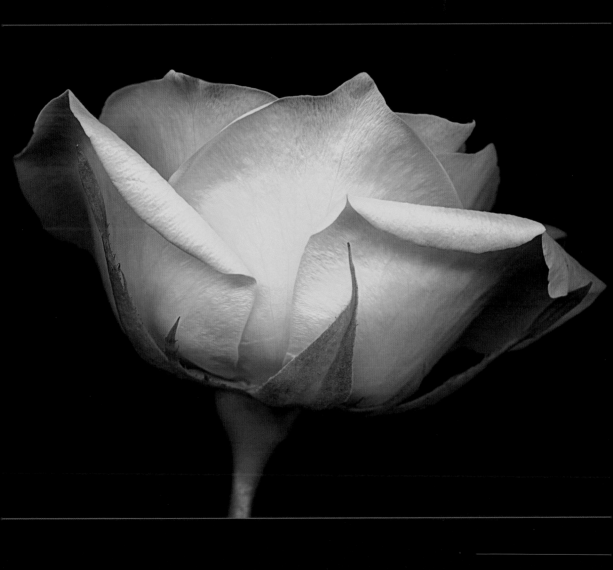

PEACE

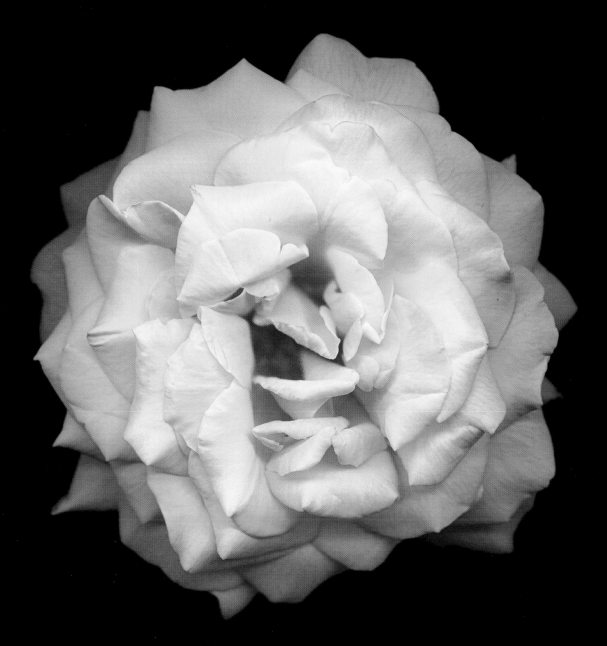

BROADWAY

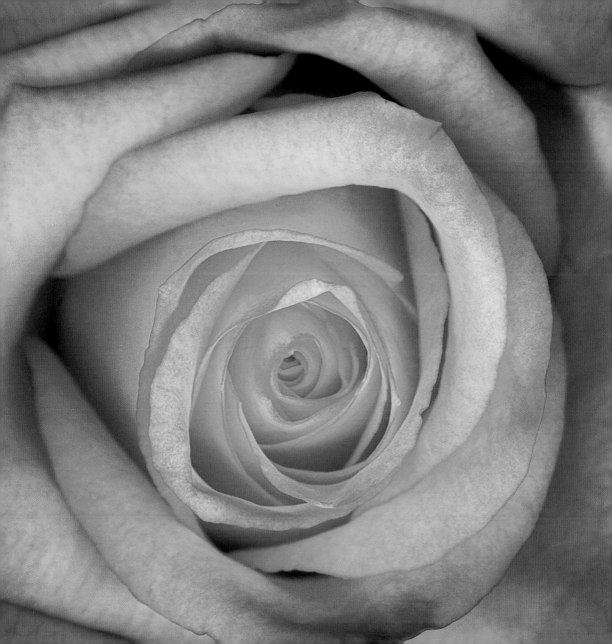

LOUISE ODIER

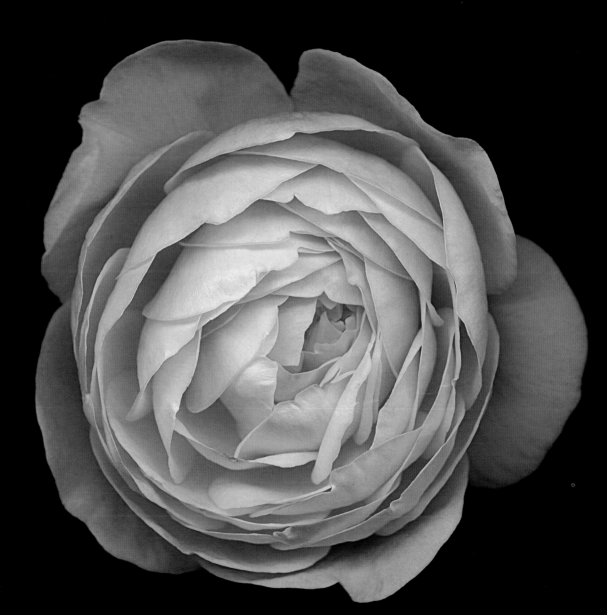

BABY MICHAEL

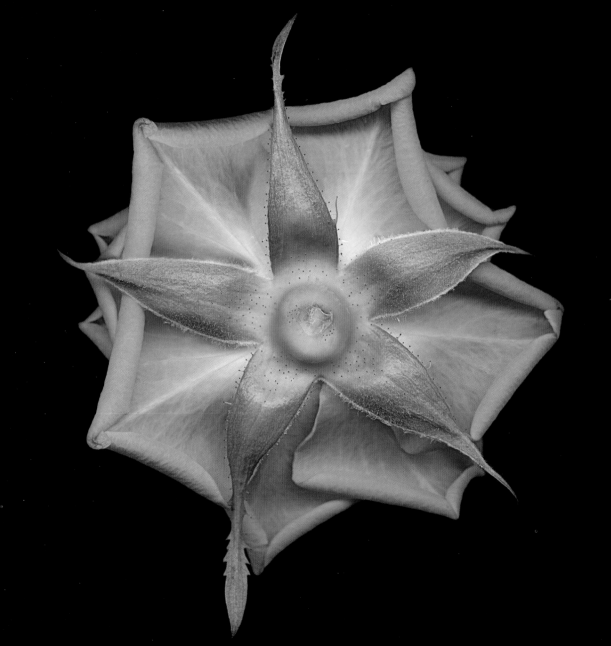

BLANC DOUBLE DE COUBERT

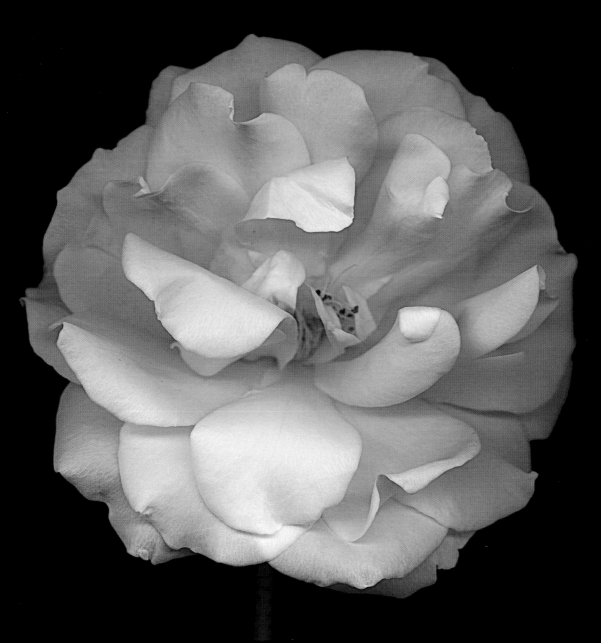

FIGURINE

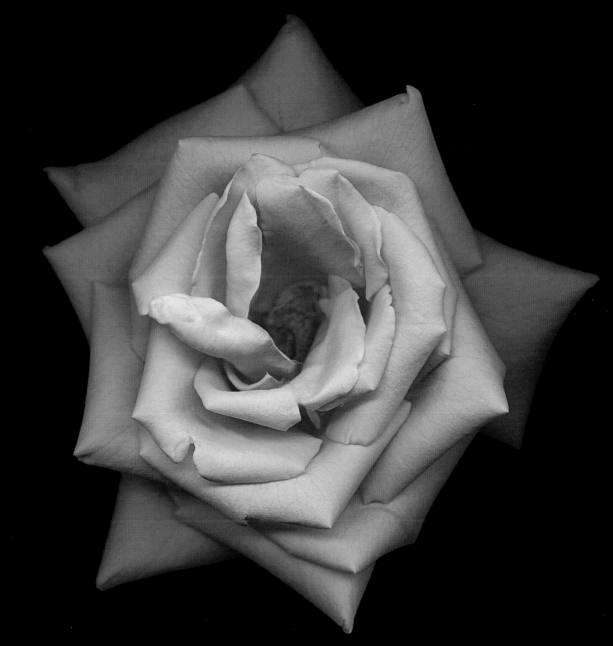

LOVE

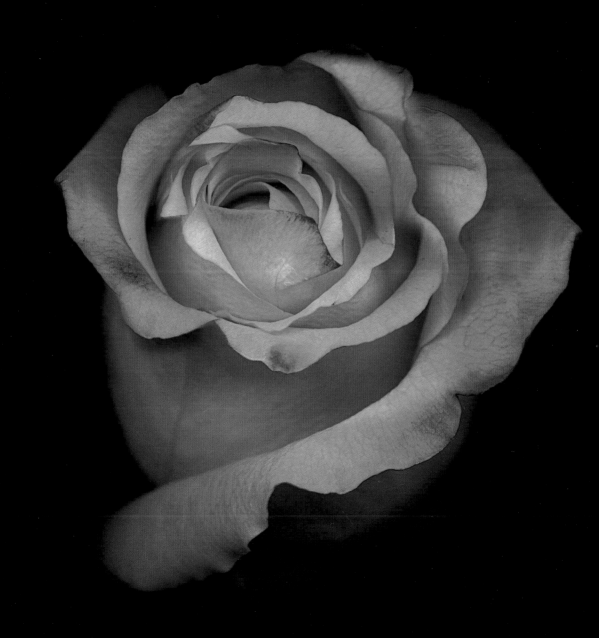

SEXY REXY

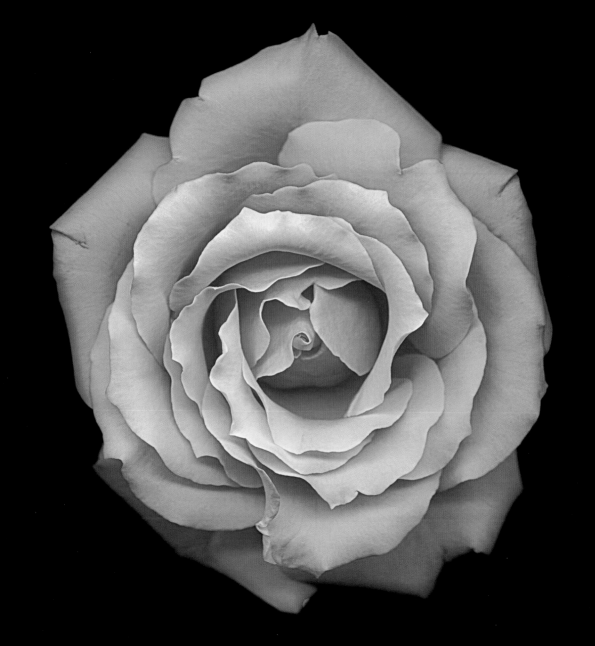

JOHN F. KENNEDY

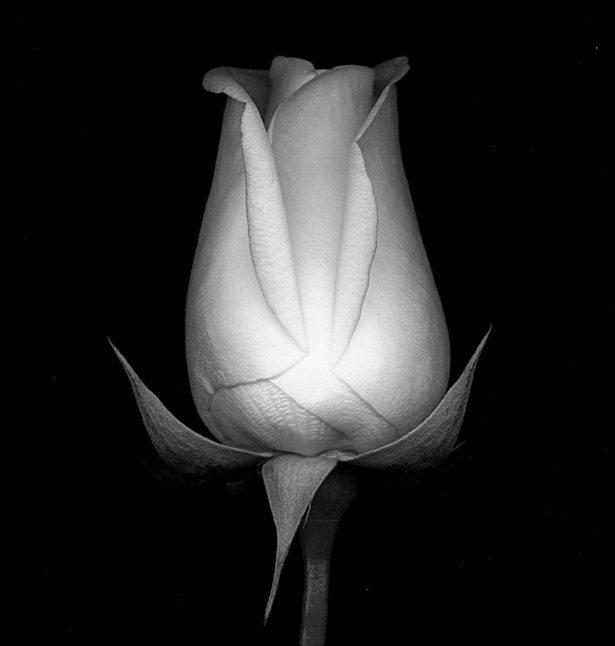

KENTUCKY DERBY

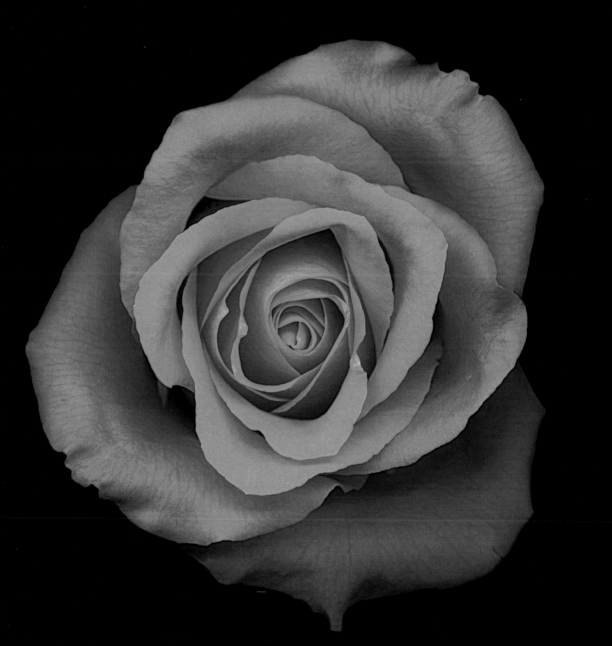

CAREFREE BEAUTY

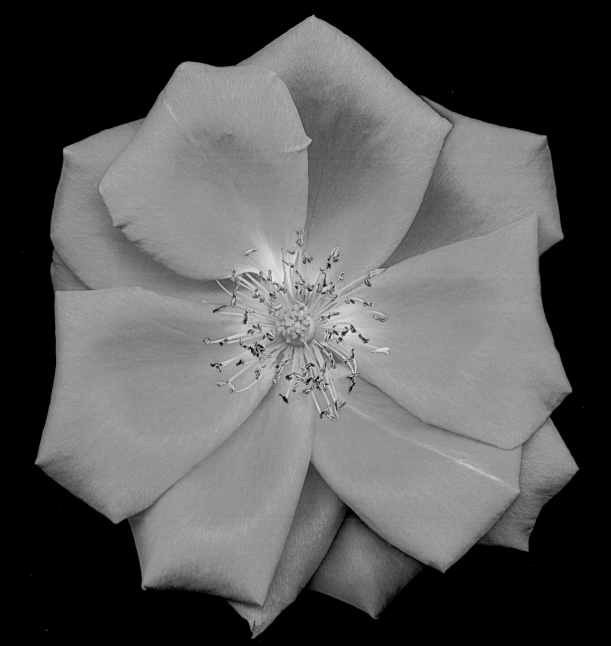

FRITZ NOBIS

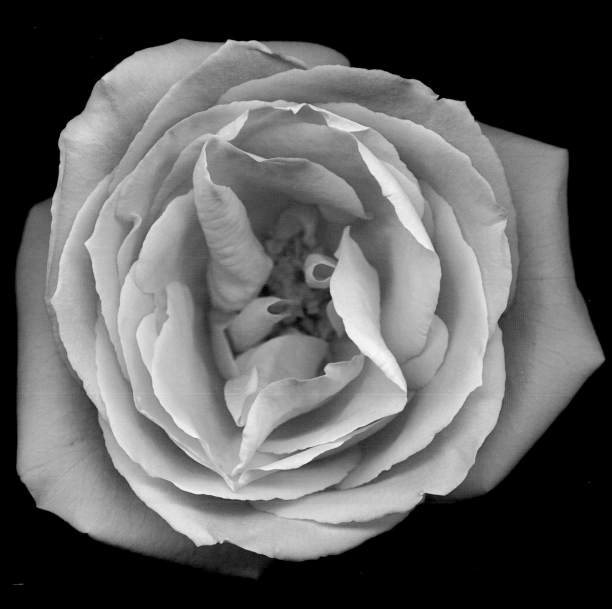

GRACE DARLING

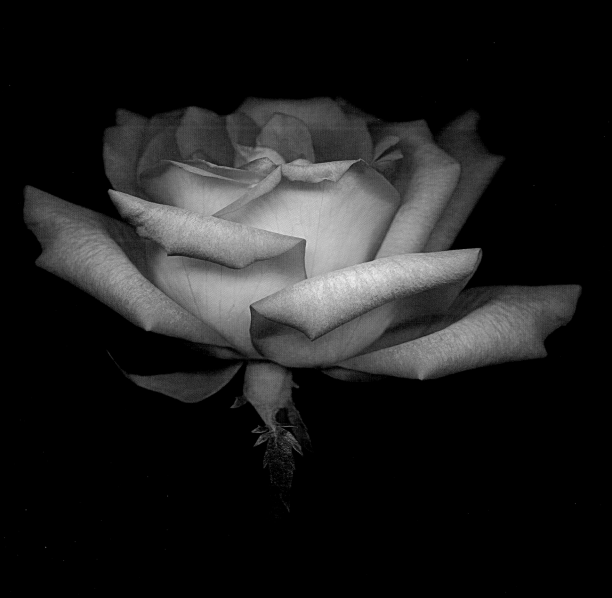

RUGOSA

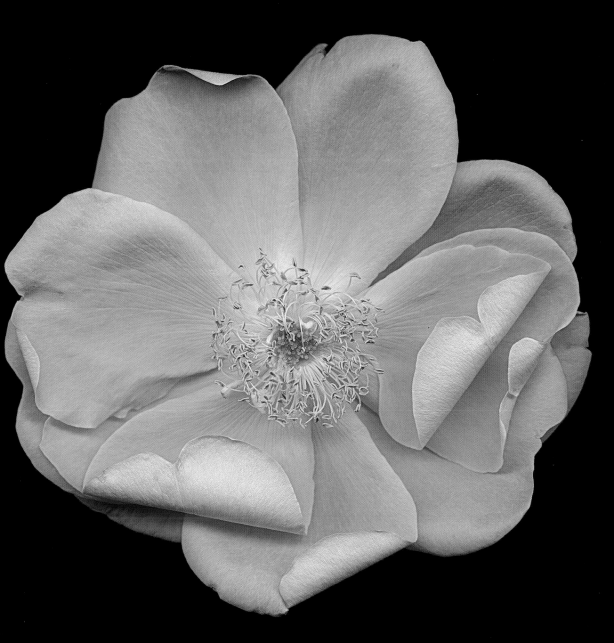

JEAN GIONO

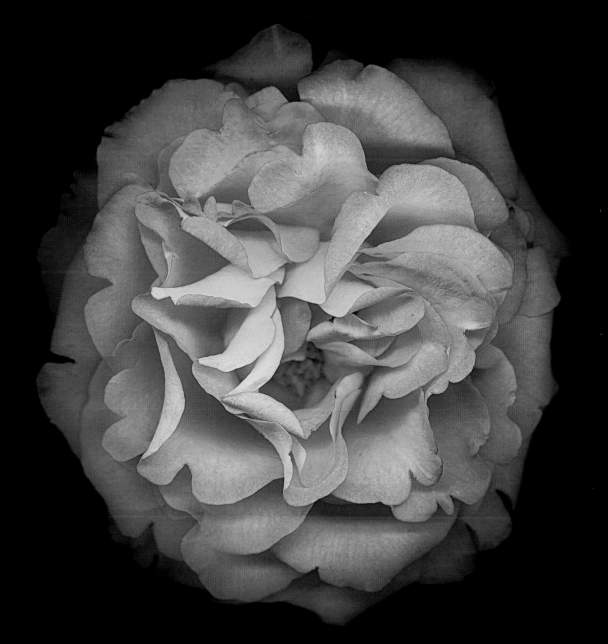

QUEEN ELIZABETH

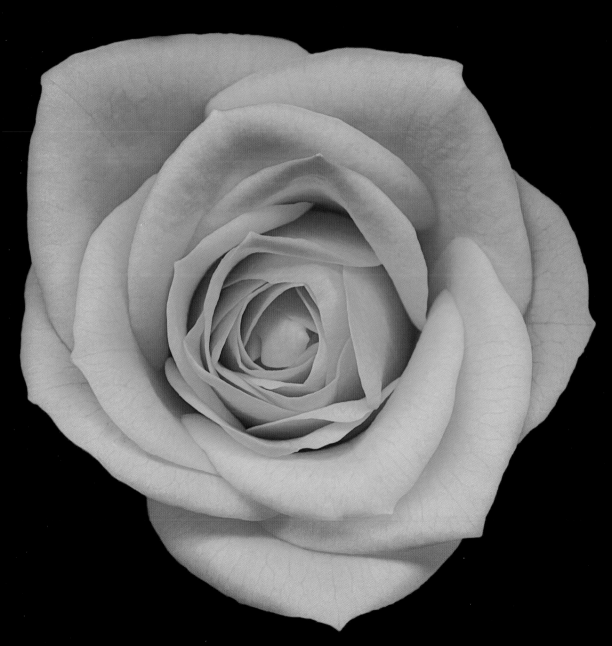

KENT

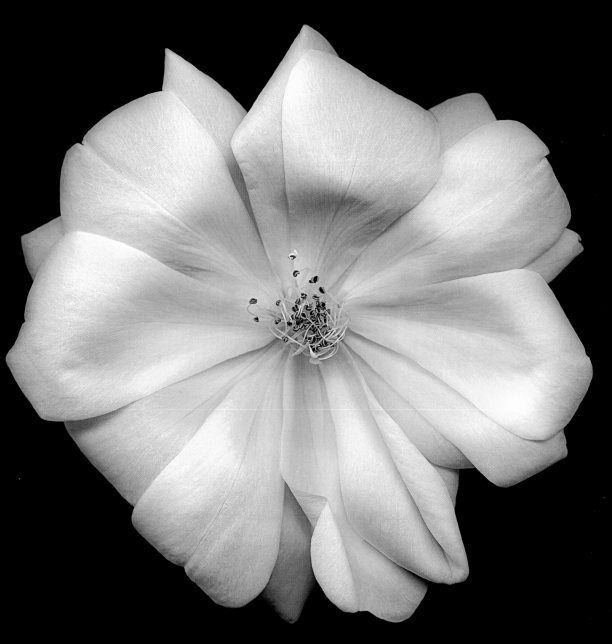

RAINBOW NOISETTE

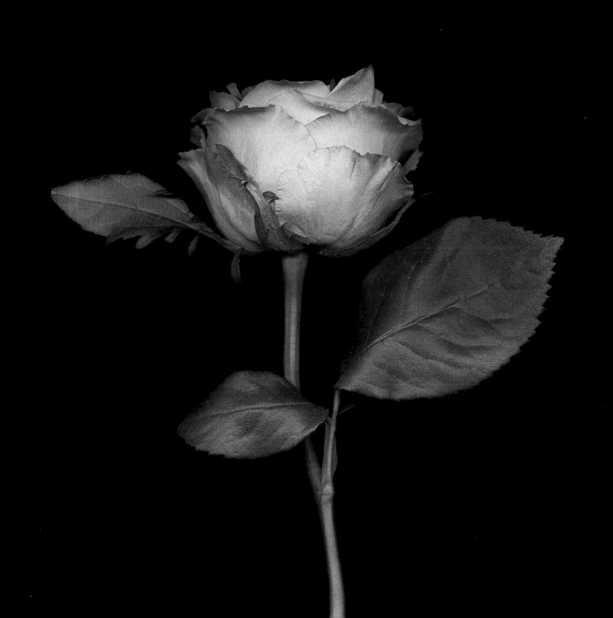

SUMMER FASHION

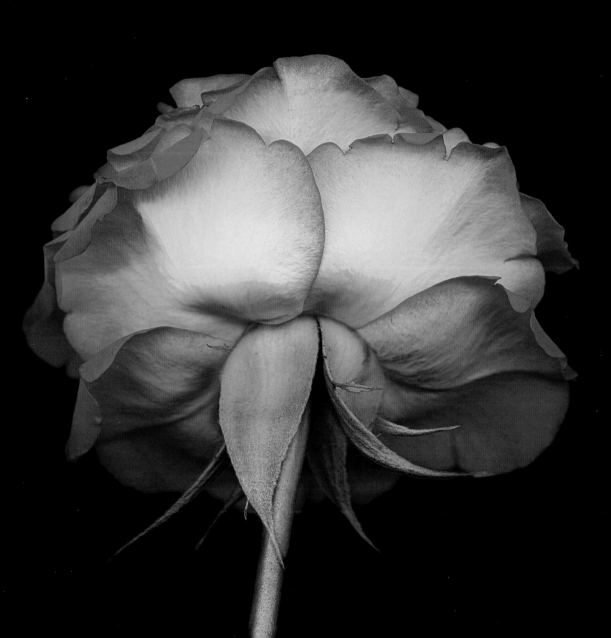

RED ROSE

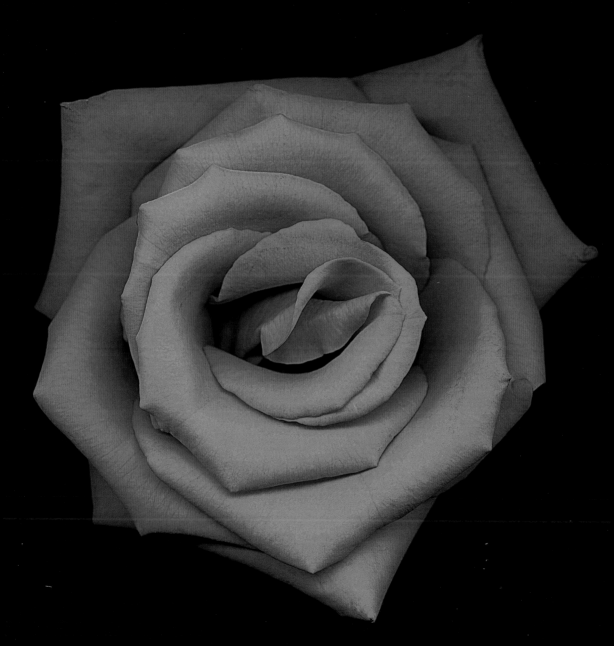

SARAH VAN FLEET

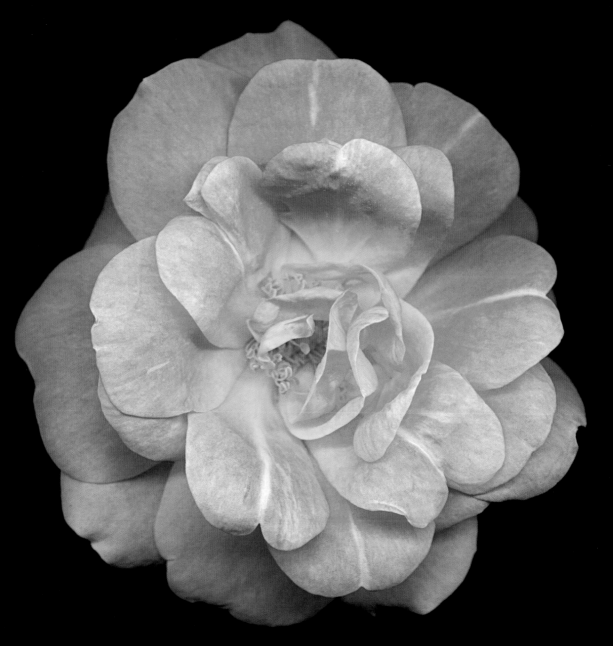

FIGURINE

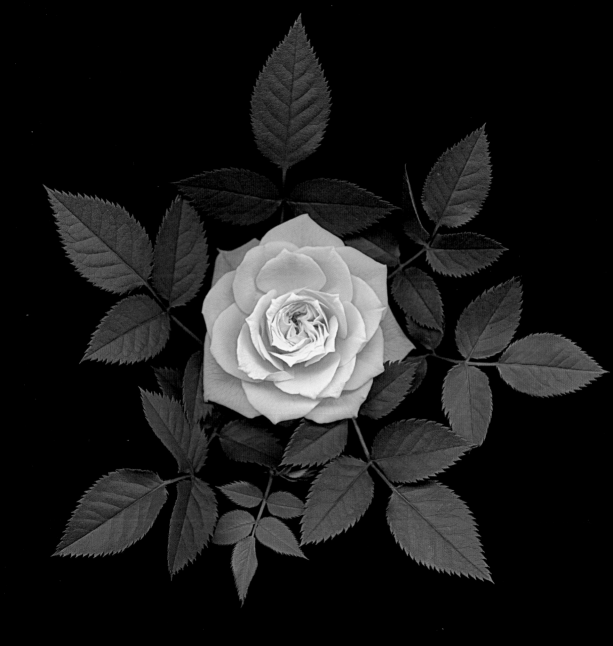

AMBER QUEEN

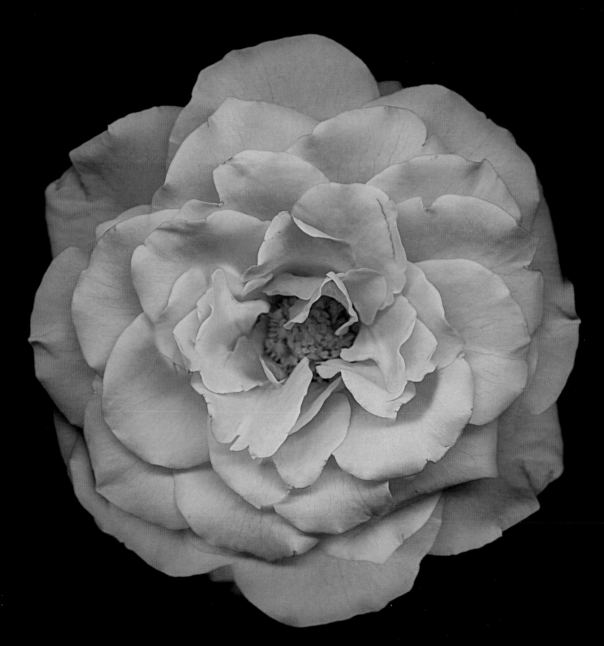

OHIO BELLE

OVERLEAF

SUMMER FASHION

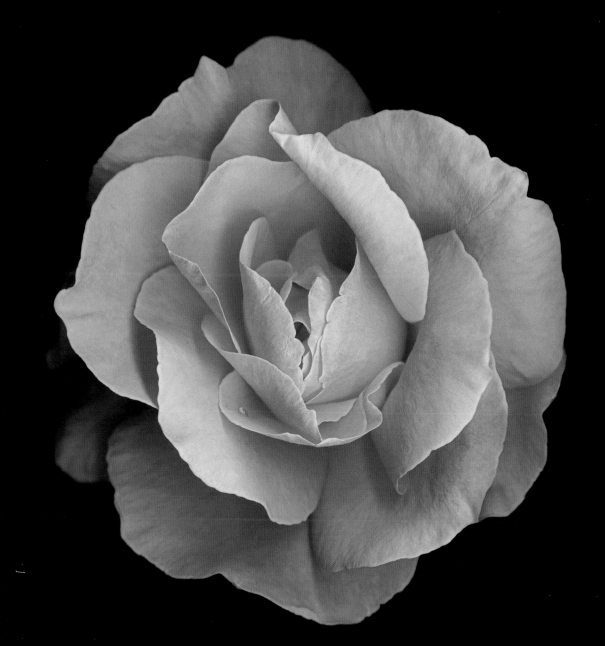

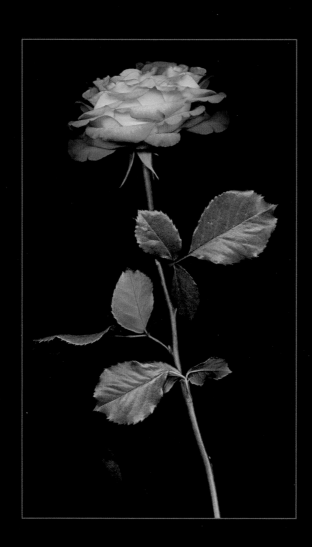

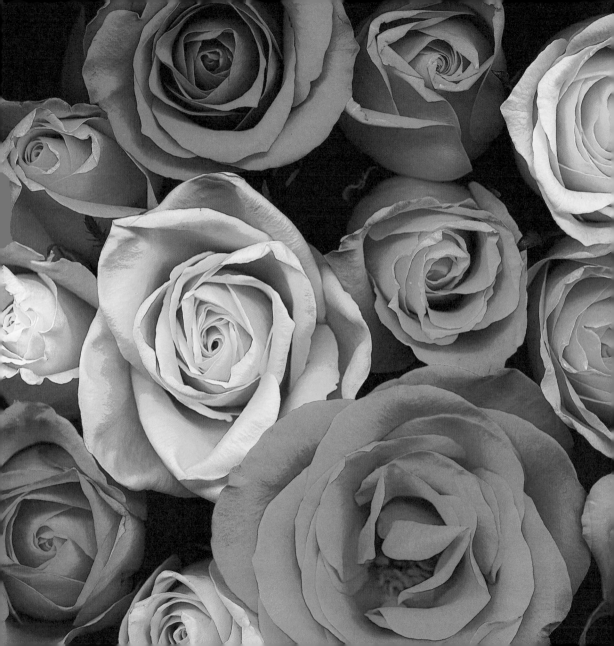